Cleveland Center for Contemporary Art

Jane Hammond

The John Ashbery Collaboration, 1993 – 2001

With texts by

John Ashbery, Ingrid Schaffner, and Jill Snyder

Cleveland Center for Contemporary Art

This catalogue has been published to accompany the exhibition
Jane Hammond: The John Ashbery Collaboration, 1993 – 2001

Curated by Jill Snyder

Cleveland Center for Contemporary Art
December 13, 2001 – March 3, 2002

The Contemporary Museum, Honolulu
March 29 – June 2, 2002

Blaffer Gallery, The Art Museum of the University of Houston
September 28 – December 15, 2002

Editor: Larry Clifford Gilman
Design: white.room productions, New York
Printed and bound in Hong Kong by C&C Offset Printing, Ltd.
Photography: Peter Muscato, Zindman-Fremont (p. 27)

Library of Congress Card No. 2001090364
ISBN 1–88035–20–2

Available through:
D.A.P./Distributed Art Publishers
155 Avenue of the Americas
New York, New York 10013
Tel: 212-627-1999
Fax: 212-627-9484

This exhibition and the accompanying catalogue have been generously sponsored by
American Greetings, Elizabeth Firestone Graham Foundation, Fifth Floor Foundation,
Jim Kempner Fine Art, Greg Kucera Gallery, Galerie Lelong, Lemberg Gallery,
Sharon and Thurston Twigg-Smith, and Zolla/Lieberman Gallery.

Cleveland Center for Contemporary Art
8501 Carnegie Avenue
Cleveland, Ohio 44106
www.contemporaryart.org

Front cover: *The Soapstone Factory,* 1998. Oil on canvas with mixed media, 74 x 98 inches.
Collection Stanley and Gail Richards, Des Moines, IA
Back cover: *Pumpkin Soup #2,* 1994. Oil on canvas with mixed media, 72 x 86 inches.
Collection the artist

Table of Contents

Acknowledgements 7

John Ashbery
Untitled 9

Ingrid Schaffner
Dear Reader, On Jane Hammond's Collaboration with John Ashbery 11

Plates 19

Jill Snyder
Inside The Soapstone Factory 83

List of Illustrations 87

Biographies 90

Jill Snyder

Acknowledgements

I first became acquainted with Jane Hammond's remarkable body of work in 1994 while serving as director at the Freedman Gallery at Albright College. In the ensuing seven years, almost the same duration of time that constitutes her collaboration with John Ashbery, my admiration and fascination for Jane as an artist and a person deepened. I attended Jane's gallery exhibitions, first at Jose Freire and then at Luhring Augustine. I visited her studio and explored common interests in areas of language, cognitive psychology, and cuisine. Our studio conversations extended to dinners. I invited Jane to speak in Cleveland in 1997 and she literally mesmerized Cleveland Institute of Art students with her blend of personal anecdote and erudite knowledge on art and just about any subject. I was soon to discover that no matter the subject, Jane could effortlessly enter a conversation with arcane bits of knowledge, interesting anecdotes, and mention of a pal who happened to be the leading expert or writer on the subject. This thirst for information, for decoding complex systems of communication, for connecting the most interesting and unusual trivia is germane to appreciating Jane's stature as one of her generation's most innovative painters.

As a heralded mid-career artist, the decision to mount a significant solo exhibition of Jane Hammond's work is timely. The focus on the eight-year collaboration between Jane and poet John Ashbery offers a natural framing of a body of work that extends back to the late 1980s when Jane instituted the conceptual system that guides her creative work. We are fortunate to have the full and enthusiastic cooperation of the lenders, listed separately in this catalogue, who have so generously parted with their paintings for the duration of the tour. My deep gratitude to those funders who have supported Jane over the years and who have made both this exhibition and its catalogue possible: American Greetings, Elizabeth Firestone Graham Foundation, Fifth Floor Foundation, Galerie Lelong, Greg Kucera Gallery, Jim Kempner Fine Art, Lemberg Gallery, Sharon and Thurston Twigg Smith, Zolla/Lieberman Gallery. I greatly value the critical guidance and personal support extended along the way by Mary Sabbatino, director of Galerie Lelong, which now represents Jane's work. Pamela Auchincloss oversaw the catalogue production with skill and expertise and offered intelligent input throughout the process. John Ashbery and Ingrid Schaffner provided lively and informative texts that illuminate the reader's appreciation of Jane's unique artistic voice and accomplishments. Larry Gilman served as an excellent editor. Craig McNeer was a guiding spirit throughout the project. Kristin Chambers, curator, and Ann Albano, registrar, orchestrated the exhibition logistics and complicated travel arrangements for which I am most grateful. I remeain indebted to the Center's Board of Trustees for their ongoing support of the exhibition program.

It has been a deep pleasure to work with Jane Hammond and I am grateful to her ongoing generosity, attention to human concerns, and spirited inquisitiveness. Her astute mind, humor, and passion would appear to feed that mysterious muse of artistic inspiration. For those lucky enough to find enrichment through personal contact, she remains a protean force that amazes friends and fans.

Jane Hammond's titles

Keeping the Orphan
Long Black German Heels and Back Areas
Contra-Zed - *JA thinks this means something.*
— Kibosh —
✓ Sore Models
✓ A Parliament of Refrigerator Magnets —
Midwife to Gargoyles
Bread and Butter Machine
The Friendly Sea —
Tom Tiddler's Ground
A Scratched Itch
✓ Surrounded by Buddies
✓ RSVP
Love You in the Morning
Lobby Card ———— *movies in the lobby 10"x14" color*
Irregular Plural
The Peace Plan
✓ The Human Condition Revisited
Long-Haired Avatar
The Stocking Market
Mad Elge
Prevents Furring
✓ Confessions of a Fop
✓ The Wonderfulness of Downtown
✓ The Hagiography of This Moment — *worshipful biography*
Wonderful You
No One Can Win at the Hurricane Bar
Night Stick
✓ Heavenly Days
✓ Pumpkin Soup
Hand Held
Good Night Nurse
Part Time in the Library
The Mush Stage —
Forests of Fire
The Soapstone Factory
Do Husbands Matter?
Dumb Show
In Noir et Blanc — —
The National Cigar Dormitory —
— You Saw It First Here —
— Freezer Burn
Man Overboard
✓ *Sea of Troubles* *JOHN ASHBERY*

(Hamlet)

John Ashbery

Imagine that a pack of giant tarot cards has been washed away on a flood and ended up in the basement of a parking garage where a splinter group of freemasons is about to hold its annual revel. Or that you've landed on a Pilgrim's Progress-like board game where almost every square spells trouble, in the form of a skull, a forbidding set of false teeth, or something less pointedly ominous. Or that you've wandered into the warehouse where the Ark of the Covenant got squirreled away in Raiders of the Lost Ark, on the day of its annual sale of unclaimed items, which include bats, butterflies, Balinese shadow-puppets, and a gargoyle in a Henry Darger pinafore. If you can contemplate these not-unalloyed delights with something like pleasure, you're ready to step up to the ticket window of Jane Hammond's retrospective show, where further unsettling treats await you.

Actually it's being billed as a Jane Hammond-John Ashbery event, so I must claim credit for at least a little of the colorful chaos on display. Some years ago (how many? the years zip by so fast these days) Jane asked me to supply her with a list of titles for paintings. In about four minutes I had made a tour of a walled-off room somewhere in my subconscious and returned with a clutch of "titles" which were actually labels of curios in my own musée imaginaire. They seemed new and shiny, like packages on Christmas morning. But they had a special pathos for me in that they were gifts somebody else was going to unwrap and play with. I was supplying the wrapping paper and ribbon, which I hoped would be as bright as possible. In return, Jane would reward me and her other fans with a new set of worlds like Wallace Stevens's "completely new set of objects." Cool, multicolored, cruel, dainty, hair-raisingly funny, they remind me of what Jean Cocteau wrote about Raymond Roussel, one of Jane's and my major influences: "a suspended world of magic, elegance, and fear."

For as long as I can remember I have had a recurring dream where I am in a kind of museum-attic in a mansion that is open to the public. I begin walking down an aisle where mountainous jumbles of weird and occasionally beautiful objects are piled on either side. It could be scary but somehow it isn't: I know I'll eventually get to the exit. And at the end there is a tremendous sense of refreshment that doesn't seem to have been produced by any of the nutty exhibits I've walked past, yet it couldn't have come from anywhere else. This terrific effervescence, life-affirming and life-transcending, I also get from Jane Hammond's collection of patented marvels. If Raymond Roussel was, in Louis Aragon's phrase, "president of the republic of dreams," then Jane Hammond is the republic's P. T. Barnum, open and ready for business, eager to baffle us for our own betterment.

Left: John Ashbery's titles as faxed to Jane Hammond, June 1993. Marginalia by the artist.

Ingrid Schaffner

Dear Reader,
On Jane Hammond's Collaboration with John Ashbery

Here are a few selections from Jane Hammond's overloaded bookshelves:

The Introduction to Solids

Phrenology, A Practice Guide to Your Head

Houdini on Magic

The Hiawatha Primer

Games of American Indians

Everybody's Marionette Book

Swimming the American Crawl

The Young Folks' Encyclopedia of Common Things

The Encyclopedia of Needlework

The Polar and Tropical Worlds

Zig-Zag Journeys in the Classical Lands

Storage Batteries Simplified

Grow Your Own Fruit

Fresh from the antiquarian book fair, a beautifully printed series on Japanese culture—from Bunraku to Sumo—spills out of a package onto the floor. Hammond's collection includes plenty of art books, of course: *Indian Court Painting, Kurt Schwitters, Jess, Life with Picasso, Mimbres Pottery*. Monographs on Georgia O'Keeffe and Frida Kahlo are prominent, too. More representative, however, are Hammond's twenty books on beekeeping, though this topic might seem irrelevant to being a painter in Manhattan. The bee books are exemplary of the many titles on Hammond's shelves that exude "bookish capacity," the air of being ready to convey definitive knowledge and offer authoritative instruction on any elected topic—taxidermy, say. It's a dated conceit, this compact authoritativeness, so there are many dark cloth bindings that glitter with gold lettering. Such ornamentation befits that golden age of popular publishing that erupted in the nineteenth century with the serialized novel and reached its zenith during the 1950s with series for young folk, for girls, for boys, for everybody. The most succinct expression of bookish capacity is the encyclopedia, and Hammond's library abounds with the single-volume sort. The dearth of new paperbacks and shiny dust jackets is a sign that the era that Hammond's library celebrates is over. Less cocksure, today's nonfiction book is an authored text limited and shaped by social, political, and cultural forces that are all subject to question and critique. In the meantime, the encyclopedia has been eclipsed by the Internet—a wonderful tool, incidentally, for buying old books.

The heaps of books Hammond owns have little to do with historical or contemporary art per se, but a lot do with her own art. The collaboration with poet John Ashbery that is the subject of this exhibition only underscores the fact that Jane Hammond's encyclopedic, poetic, capacious, Postmodern paintings are very much about books and reading.

Take *Long-Haired Avatar* (1995), with its typical construction: a collage of disparate images painted in oil on top of another collage made of images printed on paper and stuck to the canvas. In terms of first impressions, the painted part of the picture is strong and graphic (a quick read) compared to the printed matter, which is barely legible, almost painterly (a slow read). The figure at the center of the composition, with tresses flowing, clues us to the source of this composition: Sandro Botticelli's *The Birth of Venus* (c. 1485). As expected (given this origin), a long-locked attendant rushes in from the right. But to the left, instead of the entwined male and female manifestations of wind and breeze that wafted Venus to shore there is a gigantic hennaed hand emerging from a tornado of white paint.

This disruptive hand actually fits harmoniously with the welter of images of cosmologies, apparitions, and associations that ricochet off the words in the work's title, the images in Botticelli's painting, and each other. It helps to know that the word *avatar*, meaning a remarkably complete manifestation of a person or idea, comes from Hindu legend. (And, incidentally, the image of the hand comes from a booklet of henna designs that a friend of the artist brought back from India.) The *avatara* is one of the incarnations of Vishnu in animal or human form in each of the great cycles of time. The rabbit puppet popping into view holding a wire globe with a bird inside might be a variation on this theme. Further research discovers that the little candle perched on the edge of the goddess's clamshell may signify a paternal phallus: Venus was conceived when her father's severed genitals were tossed into the sea. Did I mention that Venus is wearing an Iroquois mask? Still, what is she an avatar *of*? Is she the very embodiment of the artist, whose longish hair is also blond? Or perhaps of one of Picasso's ferocious *Demoiselles D'Avignon*–yet another nude behind a tribal mask? Or maybe all of the above: goddess, artist, whore? You see where these readings are leading: everywhere at once and nowhere in particular, but always deeper into the painting, which has all the pictorial depth of a stage set. Indeed, a row of little stages is lined up accordion-fashion along the bottom edge of the canvas. Out of the flatness of Hammond's painted proscenium a magician's hand thrusts; a deck of cards tumbles from inside his sleeve. Never withholding, Hammond shows that her work is nothing but artifice, a fiction full of tricks and games. Indeed, she's quite generous in revealing her strategies, which brings us back to the books on her shelves.

The images in Hammond's art look like illustrations clipped from the books she collects, and indeed these do provide source material for her art—that book about Houdini, for instance. But more than this, Hammond's books create the same illusion that her paintings create and undermine. One gets the idea from her picture-glutted

canvases that they contain every known thing, from avatars to zeppelins. But just the opposite is true. Hammond came to art in the early 1970s, having attended a liberal arts college where she studied sculpture and science and honed her sense for structures and systems. Yet in that heyday of minimal and conceptual art, her eye was for the pictorial. How to reconcile these internal and external forces? Hammond's solution, based on over a decade of work, was to set herself rules within which she could make paintings: two sizes of canvas, six colors, and 276 images to choose from and combine. The images are numbered and the numbers, cited in strings, provided Hammond with a way of titling these works.

Hammond's resourcefulness is reminiscent of that of Lady Murasaki Shikibu, another woman who retaliated against a restrictive (and masculine) clime with imaginative invention. To battle the boredom of her life in the royal Japanese court, Lady Murasaki wrote her first novel circa 1010. *The Tale of Genji* gave Shikibu something to write; Jane Hammond's rules give her something to paint.

Hammond arrived at her system in step with the arrival of postmodernism, and it is in keeping with that movement's tenets. Postmodernism made *reading* the appropriate form of engagement for those strategies that informed the new art of the 1980s: appropriation, mediation of signs, the deconstruction of pictures as texts. This new art included, by the way, a noticeable increase in painting. Hammond's use of appropriation (all 276 of her images are reproductions) certainly contributes to the making of a lexicon in which each image functions like a word. And also like words, the meanings of these images mutate depending on what surrounds them. But compared to the postmodernism of, for instance, David Salle, Hammond offers a generous alternative. Instead of using pictorial quotes to cancel out the possibility of making something new (thus flagging the emptiness of all visual signs, including words), Hammond's work embraces the artist's capacity for making meaning, or meanings, even if they are fugitive or absurd. Following Hammond's constructive approach, if you find yourself lost in the forest of signs, why not practice a little woodcraft? (See *Woodcraft*—on Hammond's shelf.)

Although many of the titles of the works in this exhibition sound as if they were copied off the spines of the books in Jane Hammond's library, they were all produced according to another rule: she invited poet John Ashbery to compose a list of titles for her to paint. Hammond has long-standing relationships with several poets who, like Ashbery, have also written extensively on the visual arts. Her intrigue with poetry began with the villanelle, a French form that she learned about at a reading by the poet and art writer John Yau (the two were later married for a number of years). It is easy to imagine the appeal that this rhyming structure, based on an intricate pattern of repeating lines, would have for Hammond, who was just beginning to make paintings based on the repetition of elements. Another complex structure preoccupies Hammond in the book collaboration she is now working on with the poet Raphael Rubinstein. Rubinstein is an editor at *Art in America* magazine and an aficionado of the French Oulipo movement of poets, which in the 1960s began to explore a literature of

arbitrary constraints. Georges Perec, one of its founders, wrote an entire novel without using the letter "e." One of Rubinstein's poems for his collaboration with Hammond is written in a form of his own devising: eight stanzas of eight lines of eight words with eight letters. Pronouns are off-limits, and . . . you begin to grasp the difficulty.

Ashbery, one of the leading figures in the New York School of poets that emerged during the 1950s, was for many years a contributing art critic for the *Paris Tribune* and the editor of *ArtNews*. In a brief introduction for a 1990 exhibition of Hammond's art, he appreciated those qualities in her paintings that "leave us with . . . the sense of a ritual performed, of a change signalled, of exchanges of various kinds including sexual and alchemical ones, of a page being turned." But even barring all this background, and going simply by the forty-four titles Ashbery presented to Hammond in June 1993, the attraction is evident. Like Hammond, Ashbery's medium is collage. Put your ear to a few of his titles and you hear the slices of everyday speech and found phraseology in *The National Cigar Dormitory, Dumb Show, The Friendly Sea, Prevents Furring,* and *No One Can Win at the Hurricane Bar*. In one of the paintings born from this collaboration, *Pumpkin Soup II*, Hammond has lovingly joined Ashbery's portrait with hers; their faces are framed on the credenza, a pair of doting parents.

Collage, one of the defining techniques of Modernism, goes hand in hand with books. James Joyce's *Ulysses* would not be a modern classic without all the texts collaged into it from quotidian life. The artist Joseph Cornell's library was so significant that when the National Museum of American Art inherited the contents of his studio, they took all his books, too. Early Modernism includes several collage collaborations between artists and writers, precedents for the work by Ashbery and Hammond. Two in particular will enhance our reading. First, a Russian example: In 1923, the poet Vladimir Mayakovsky presented his friend, the artist Aleksandr Rodchenko, with a poem to illustrate. Titled *Pro Eto*, or "About This," the poem was an incantation, an attempt by Mayakovsky to hold on to the disruption and havoc of his love for Lili Brik before it subsided into comfortable habit. Its imagery jumped from telephone to troglodyte, from domesticity's mare to ice floe, in a stream-of-consciousness style that seemed specially minted for the technique of photocollage that Rodchenko was then practicing. By cutting, splicing, and gluing down everyday images, images of things that could never come together in reality, the artist manifested that shock which the poet longed to savor (and which for these members of the Russian avant-garde also signified the exciting rupture of revolution). The shock is greatest at those non-seamless moments when different kinds of reproductions collide and one becomes aware of all the corpses of photographs, of magazines, of advertisements, that have been dismembered and discarded to make this one image.

What's interesting about *Pro Eto* is its relationship to photography, another modern medium and one that haunts not only Jane Hammond's collages but all collage. Soon after completing his collaboration with Mayakovsky, Rodchenko bought a camera and learned photography, primarily for purposes of enlarging and reduction.

It was a short step to taking his own pictures. Hammond's work has its own practical relationship to photography. Not one to be hacking up her library, she relies on photocopying, projectors, and other photographic means. Concerns over archival issues—which are bound to be immediate for anyone who relies on a picture archive for their work—have led her to develop a technique for making color reproductions that will not be subject to the inherent vices of commercial printing. Hammond's use of collage is also conceptually related to photography—doubly so. For what do photographers do when they look through the lenses of their cameras? They edit and crop; they cut pictures out of the world at large, just like an artist working in collage. Thus, while the photographic nature of collage once prompted modernist Rodchenko to go out and create new pictures, it now keeps postmodernist Hammond busily reproducing and creating fresh readings of the pictures she already has.

Perhaps it comes with working from a pool of 276 images, or from her processes of reproduction, but Hammond's collage does not have the shock and schism of Rodchenko's. Searching art history for an early sensibility similar to hers, my hand lingers over a row of Max Ernst's collage books, including *A Hundred Headless Woman* (1927–29). Based entirely on engravings, Ernst's work also has a kind of seamlessness, but I find it slightly hysterical and too nightmarish to make a good comparison to Hammond's work, so I reach for *What a Life!* instead. This 1911 collage collaboration between two British satirists, the verbal E. V. Lucas and the visual George Morrow, is a fictional biography based on pictures clipped from a mail-order catalog and collaged into illustrations. As printed matter from the great era of popular publishing, the images are dead ringers for the kind Jane Hammond uses in her work. In praise of this material, the authors' preface intones: "As adventures are to the adventurous, so is romance to the romantic. One man searching the pages of Whiteley's General Catalogue will find only facts and prices; another will find what we think we have found—a deeply-moving human drama." Indeed, when the anonymous subject of the book claims to have known "slightly Sir Algernon Slack, the millionaire, whose peculiarity it was never to carry an umbrella," and the accompanying picture shows a figure in deep-sea diving suit, complete with diving bell, this reader *is* moved (to laughter).

My copy of *What a Life!* is a 1975 reprint with a foreword by none other than John Ashbery, who asserts, "*What a Life!* is a very funny book and deserves a niche in the pantheon of British nonsense. It also has a certain place in the history of modern art . . . " Terry Gilliam's collage animation for *Monty Python's Flying Circus* could be counted among its progeny. In its own day, the book was possibly known to Dadaists, including Ernst. By 1936, it had earned itself a place in The Museum of Modern Art's *Fantastic Art, Dada and Surrealism* exhibition in New York. The Surrealists would have been charmed and charged by the attack *What a Life!* made on bourgeois reality using nothing but scissors, junk mail, and humor. The fact that it took the form of a book would have made it especially appealing, for Surrealism, originally a literary movement, has always been as much about poetry as about painting. This means that no matter how arcane or absurd, silly or strange, abstract or

inarticulate a given text might be—be it words or a picture—the reader is compelled to make some sense of it. Proving this logic-defying principle sparked the Surrealists in their pursuit of chance encounters, games, collaborations, and collage; what better way to catch up with the workings of the unconscious mind or, better still, the ineffable?

There is much of Surrealism—its traditions, its activities, its aesthetic, its laughter—to be found in the works of both Jane Hammond and John Ashbery. But in this discussion's terms, it's the literalness of Surrealism—the surrealist compulsion to make things legible no matter how fantastic—that makes the Ashbery-Hammond collage collaboration tick.

From the list of forty-four titles Ashbery scripted for her, Hammond has been able to make more of some than others. For example, to date she has yet to turn *Contra-Zed* into a single painting, but she's made at least one work for almost every other title, including two *Pumpkin Soups*, three *Sore Models*, and five *Irregular Plurals*. Hammond says she never anticipated that her vow to see the list through to the end—to make each of Ashbery's titles legible in her own visual terms—would occupy eight years of her life. In the meantime, she has broken (or evolved) most of the rules she first set for herself. Her original, limited kit of colors has grown to a fully-fledged palette of every hue and shade. The language of her painting has grown increasingly complex and present for its own sake: *The Mush Stage* (2001) features a beautifully icy passage of abstraction. The introduction of the printed paper collage elements (reproducing hosts of new images) lends the 276-picture lexicon greater nuance. And the overall matrix of media, pictorial space, pictures, and background have become more densely intermingled. It's as if all the thinking that has gone into Ashbery's forty-four titles simply keeps increasing the artist's capacity for reading them on different levels or in different ways. When we encounter a hennaed hand plucking at the void in *Irregular Plural #5,* we already know it to be an avatar. To understand what an avatar *of* is, however, we must surrender our former understanding to an entirely new context. This one has to do with pairs of images that are the same but different: another hand in the picture floats on a little television screen. Other things that seem to want to go together here are the heads of two bald men (Picasso and Ghandi), the phrases "Egyptian Water Box" and "Siberian Chain Escape," a wish-bone and a wish-bone-shaped length of rope. Framed by an open book, none of the elements of these pairs is literally on the same page. At the same time the painting (and title) insist that we read them together and adjust our sense of meaning accordingly. Oh, absolutely, these are *irregular* plurals.

The Ashbery list did bring about one spontaneous change in Hammond's work. Whereas for years she had used exactly two shapes of canvas—a square and a rectangle—*Sore Models I* (1993) is a diptych painted on two supports shaped like a pair of feet. After this, there seems to have been no turning back. Shaped canvases appear the rule, not the exception, within the Ashbery group, which also features a number of multi-part pictures. There are

paintings shaped like maps, like houses, like plates, like games, like open books. And though we commonly think of closed books as being squares and rectangles, like conventional paintings, this hasn't always been the case. Not all texts are uniform lines of print that read from left to right. There are scrolls and tablets, snakes and ladders, even human bodies to contend with in the history of reading and books. Peter Greenaway's film *The Pillow Book*, named after a great work of early Japanese literature, tells the story of a contemporary female author who turns her lover's living body into a written page. The manuscript drives her publisher to distraction; he has the young man flayed and turns the printed skin into a book—a terribly unique edition. Hammond, for a new print she is making outside the Ashbery collaboration, becomes a page in her own lexicon. A selection of her icons appears stamped onto her nude body, digitally photographed from behind. The almost life-sized sheet of Gampi paper on which the image is printed may be tissue-thin, but its fibers show it to be as strong and supple as skin. And in the Ashbery project, the slightly irregular cut of the edges of one of the 20 elements in the painting *Do Husbands Matter?* references vellum, the leather material of choice for manuscript illumination.

From their very outline, Hammond's shaped canvases reinforce the iconic nature of her paintings and her works' desire to be read pictorially. Such talk of symbols and symbolism smacks of medieval times, but it's the notion of the icon that ultimately takes Hammond's use of the collage technique most firmly into the present, and possibly beyond. Computers have put a fresh spin on the established conventions of reading. Icons prompt ways of visually enhancing our reading with new fonts, formats, images, colors. We scroll up and down through screens of text; we cut and paste with abandon. Think of Hammond as having downloaded her 276 images into a database; suddenly, her painting system becomes a program for processing an ever-expanding web of information.

Having almost run through the John Ashbery collaboration, Hammond is sure to generate many new applications for her collage and, with them, many new readings.

(I would like to thank Geoffrey Batchen for reading this manuscript and for his expert input.)

Irregular Plural

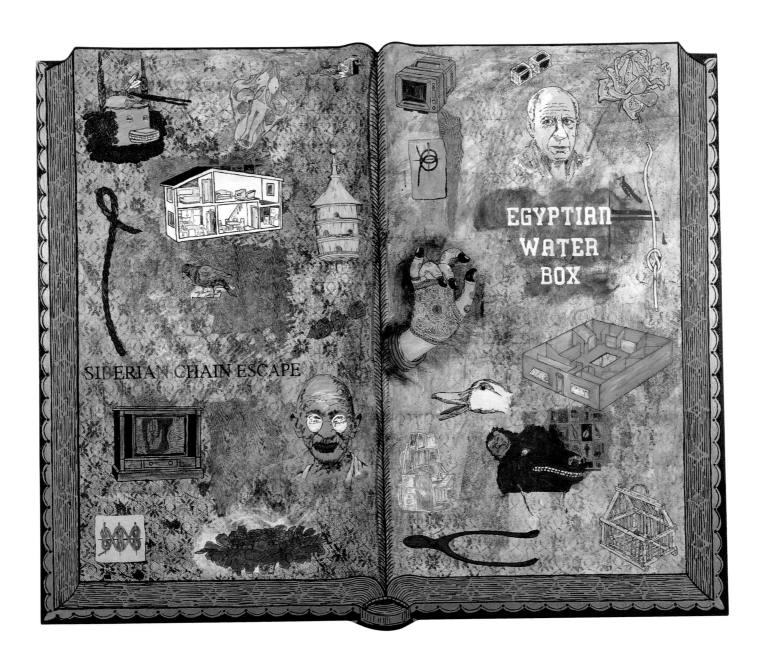

SIBERIAN CHAIN ESCAPE

EGYPTIAN
WATER
BOX

The Soapstone Factory

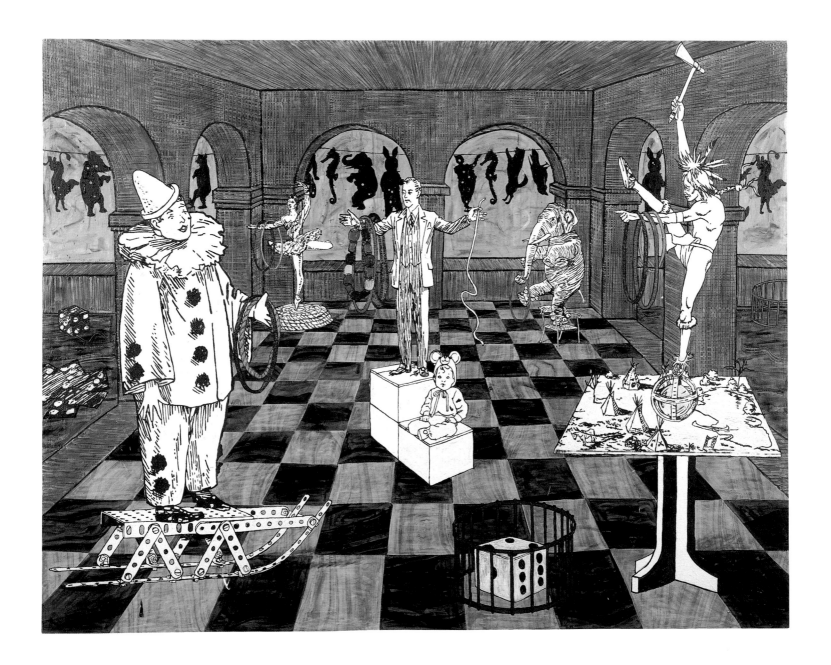

Bread And Butter Machine

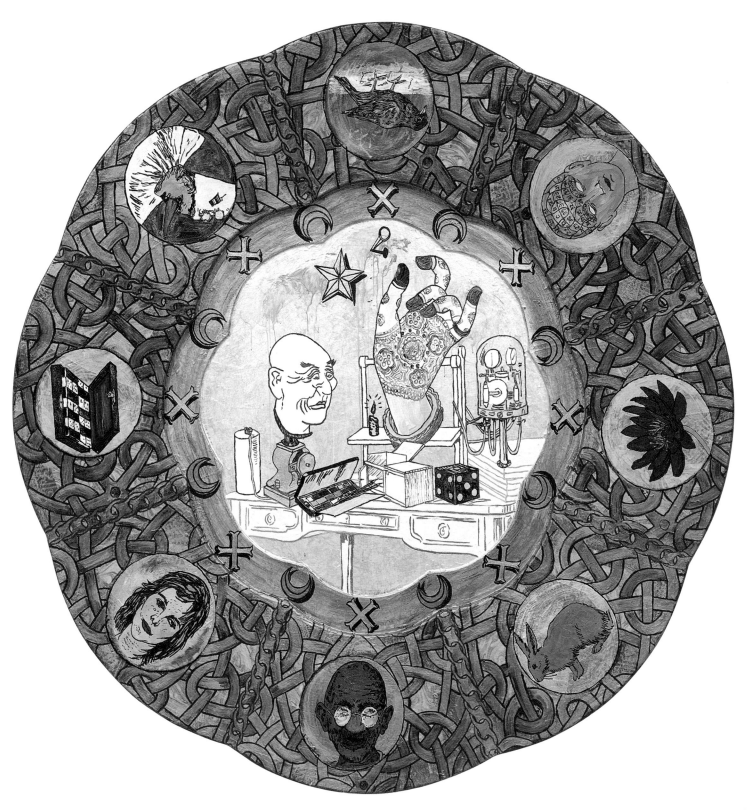

23

Sore Models

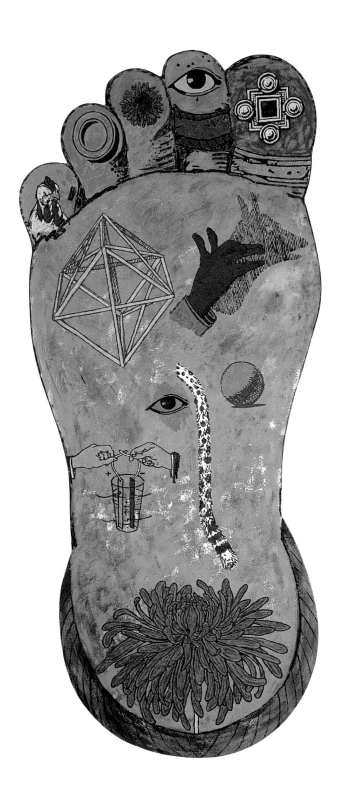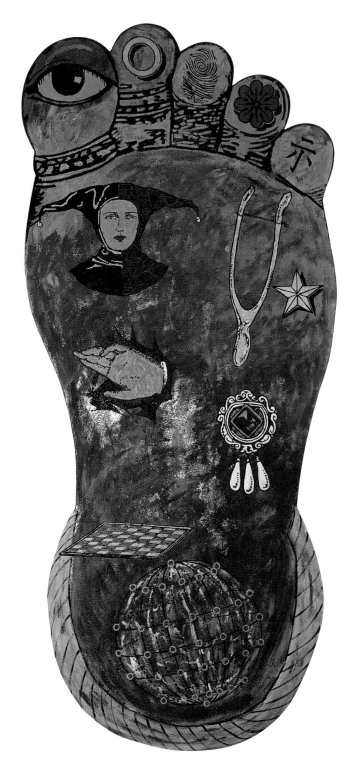

The Mush Stage

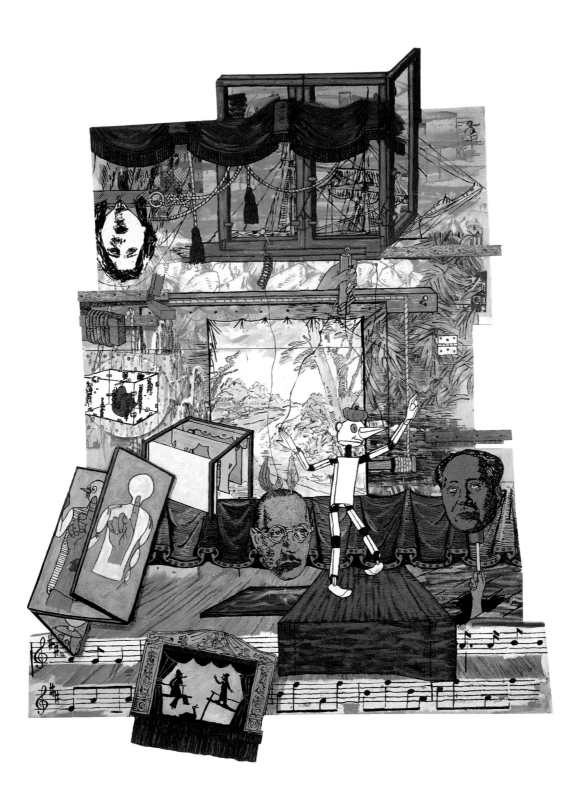

27

Wonderful You

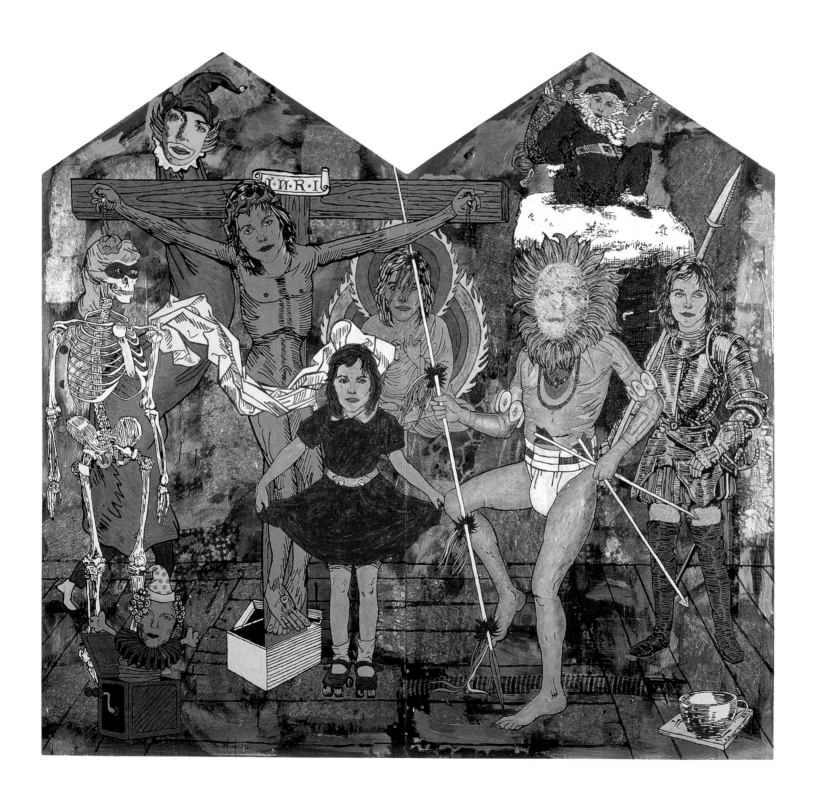

Dumb Show

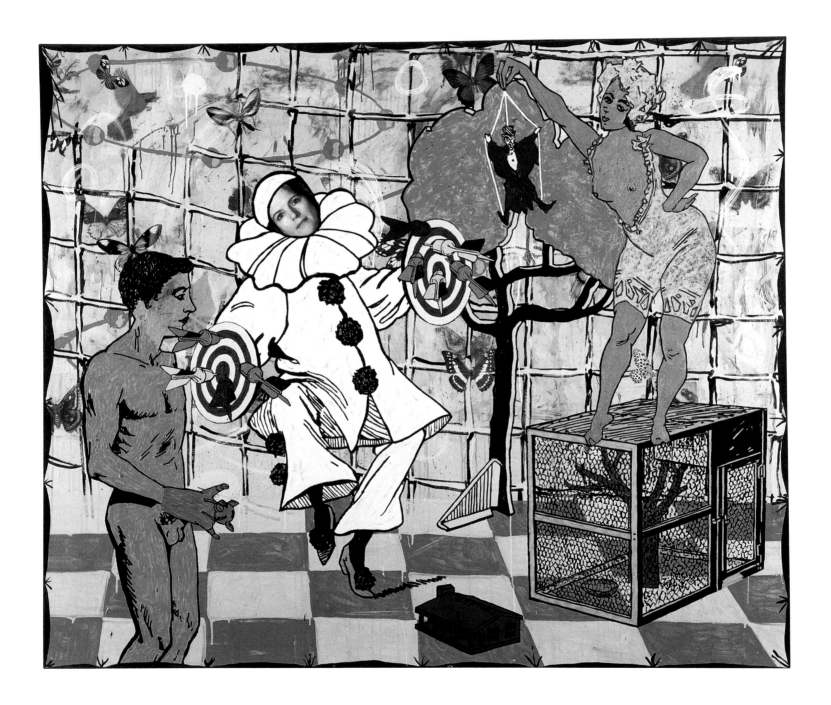

Sore Models

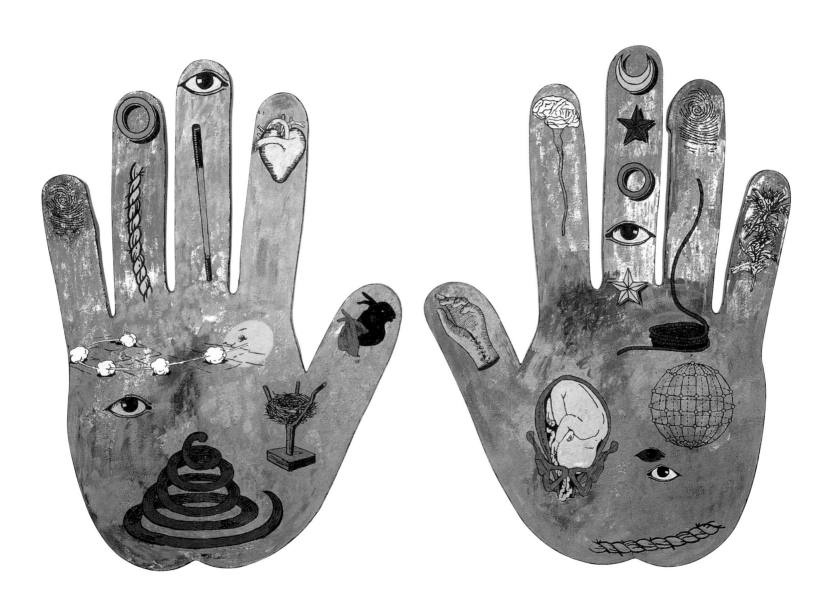

The Friendly Sea

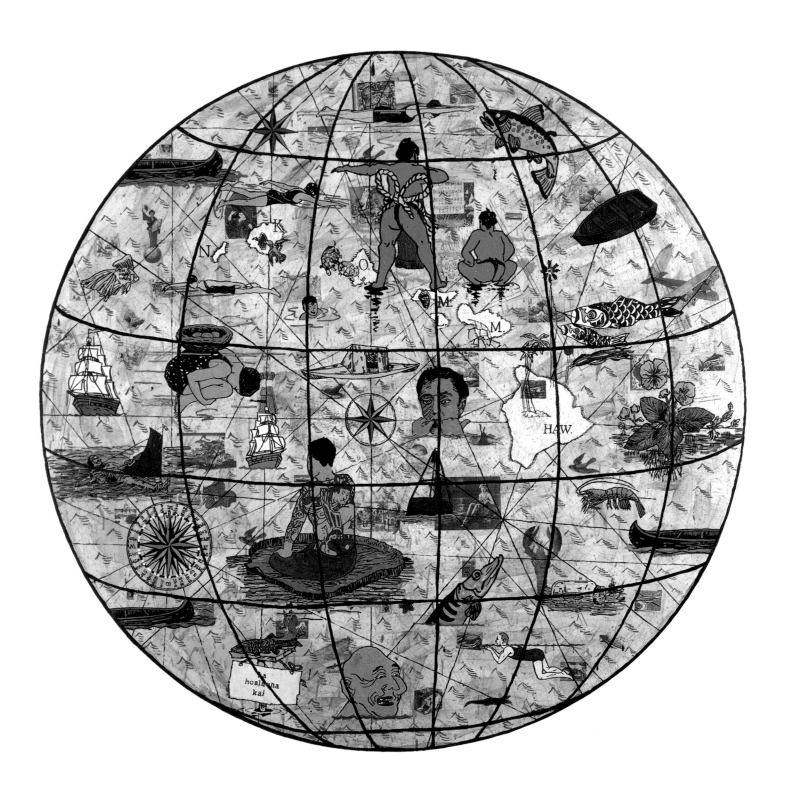

Midwife To Gargoyles

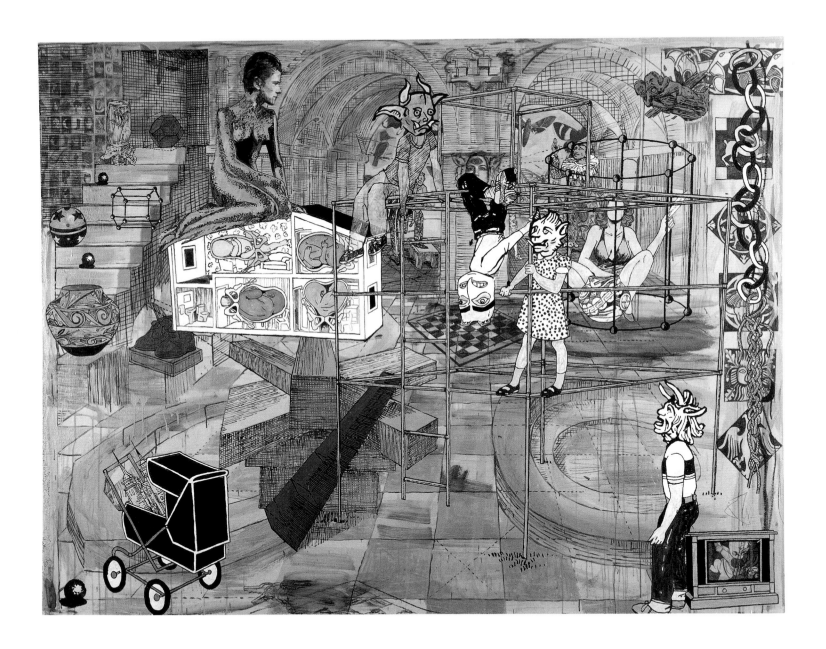

Freezer Burn

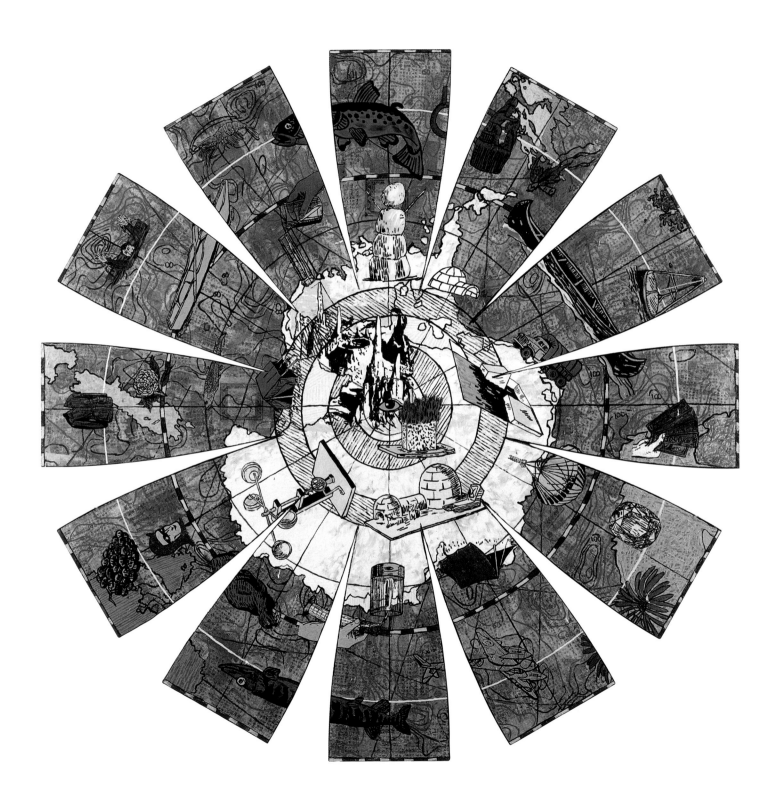

Wonderful You

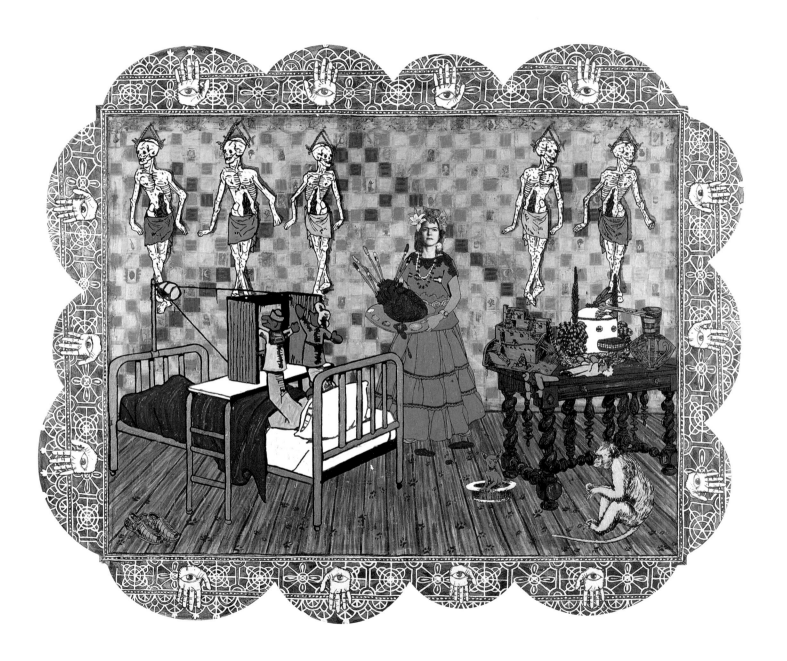

41

Surrounded By Buddies

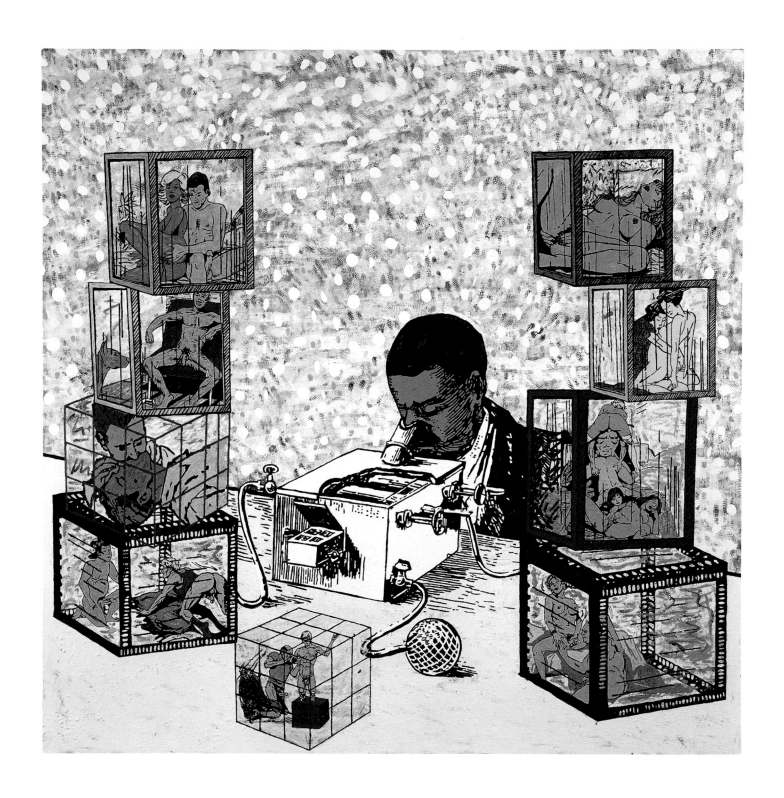

43

No One Can Win at the Hurricane Bar

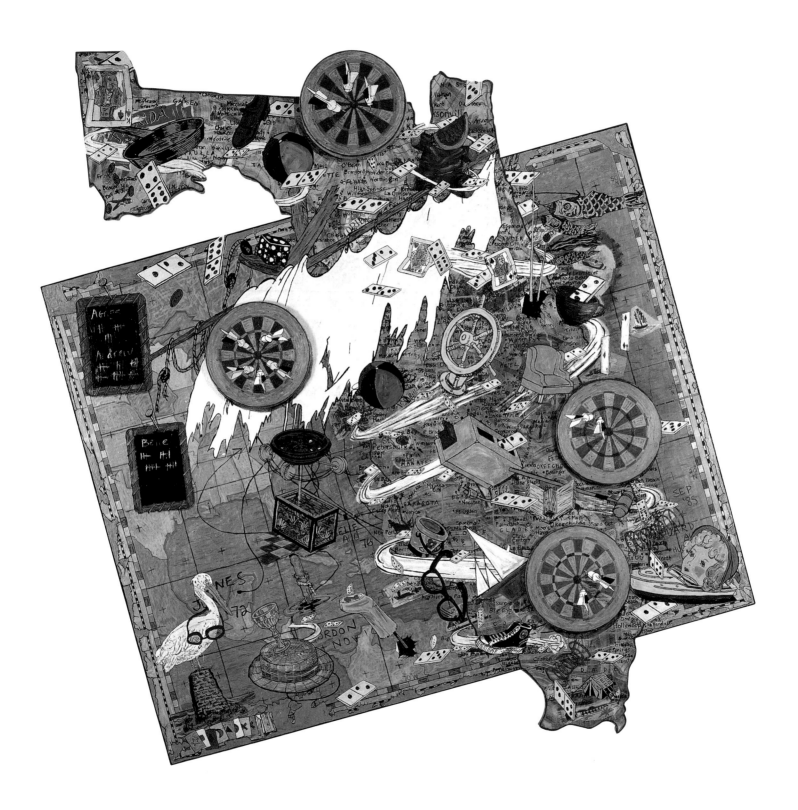

Confessions of a Fop

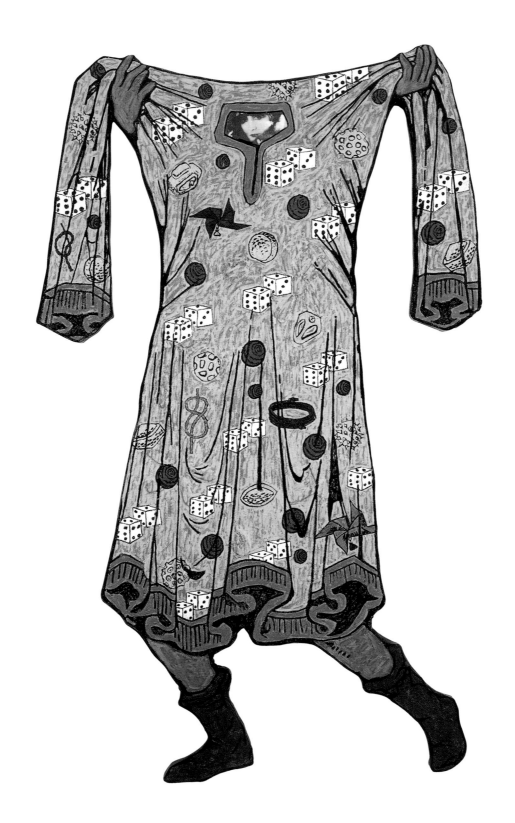

Mad Elga

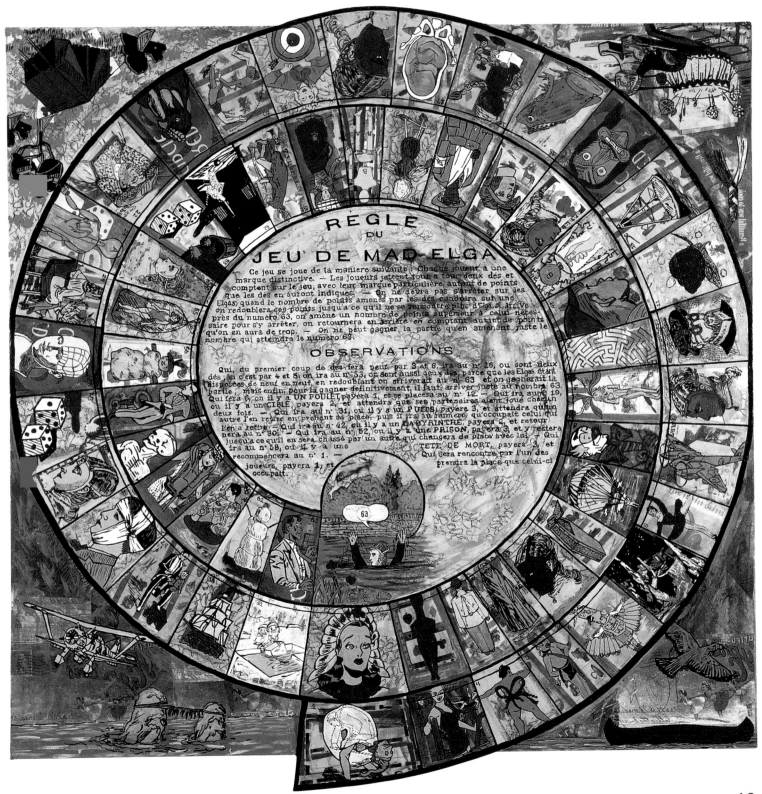

49

RSVP

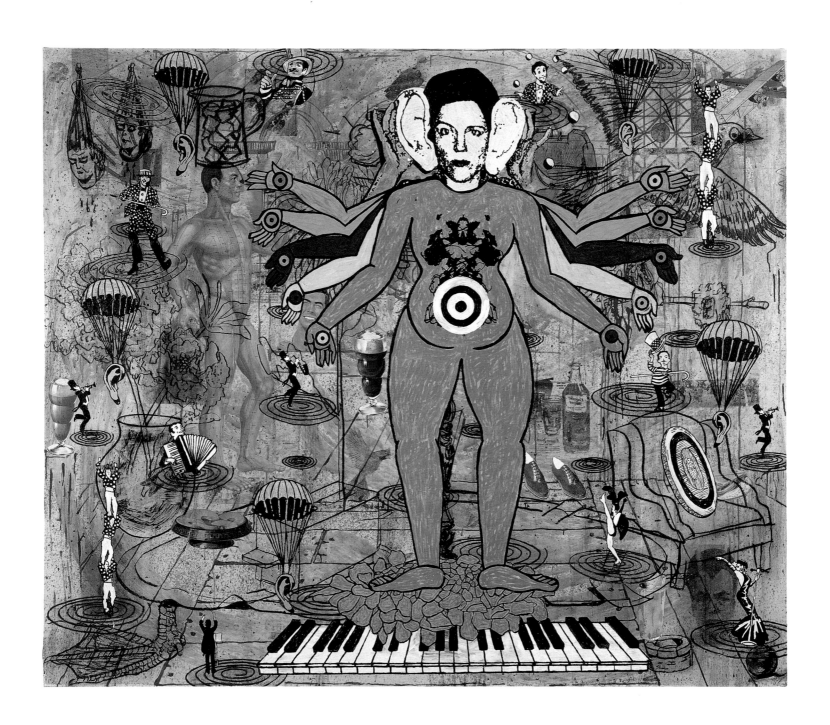

Tom Tiddler's Ground

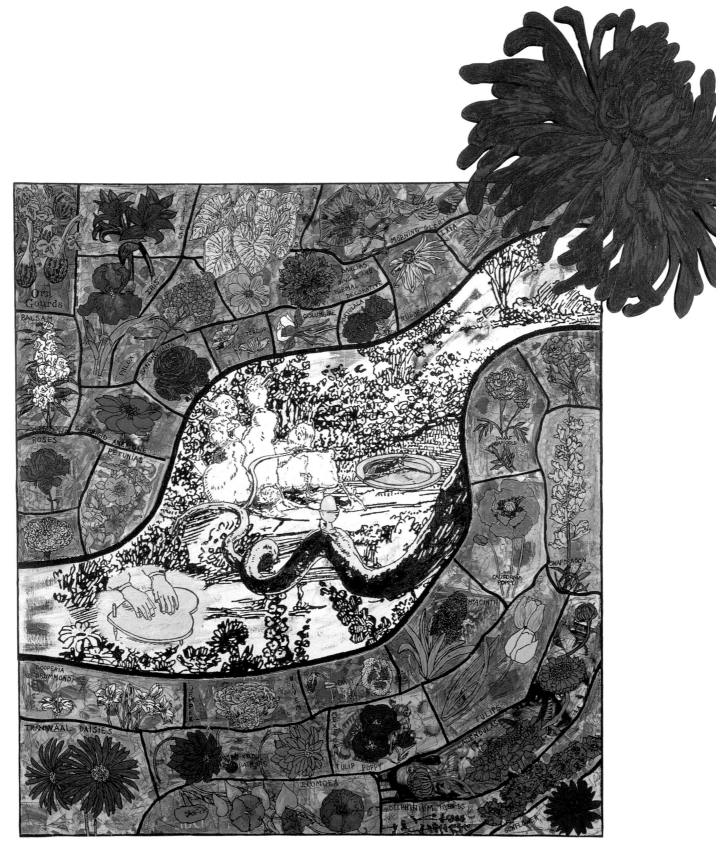

The Soapstone Factory

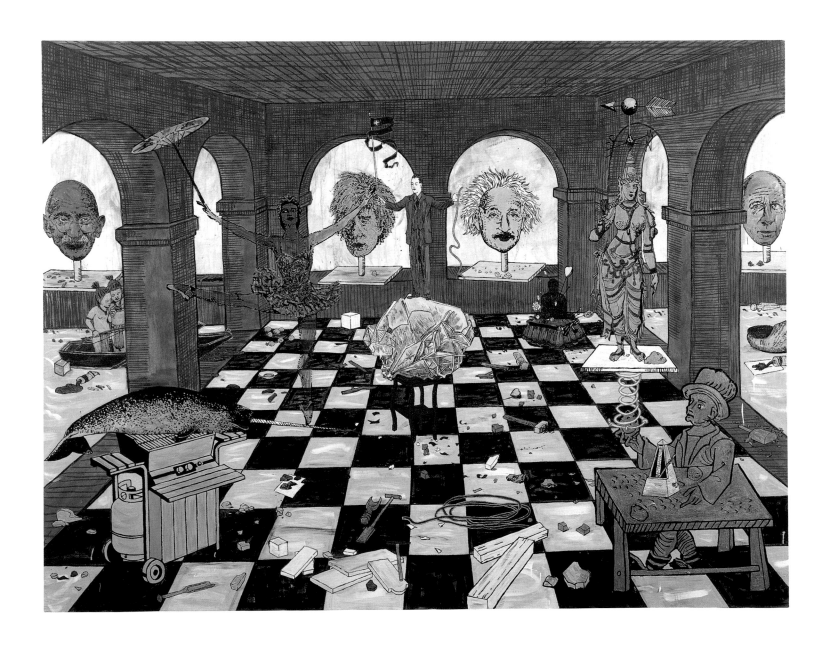

Sore Models

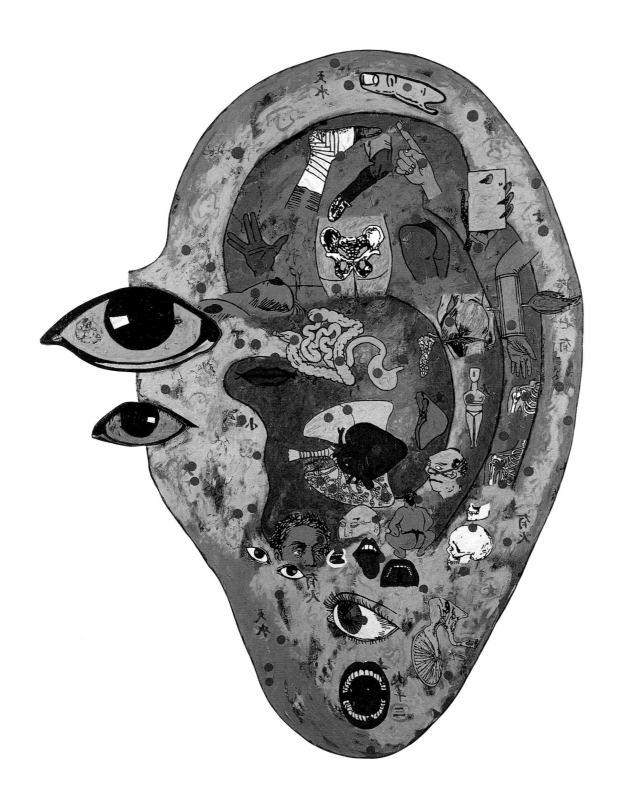

The National Cigar Dormitory

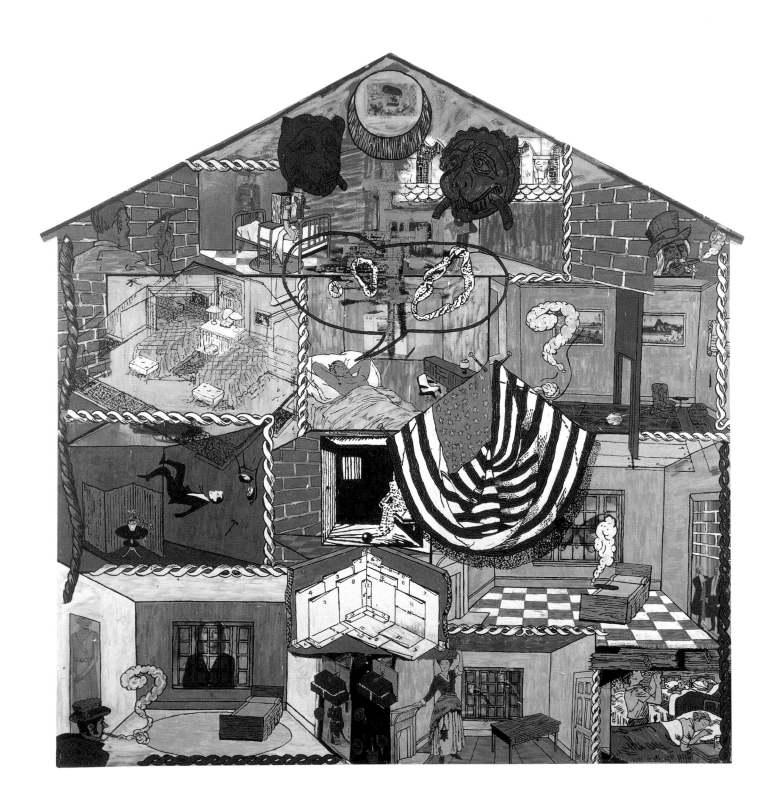

Wonderful You

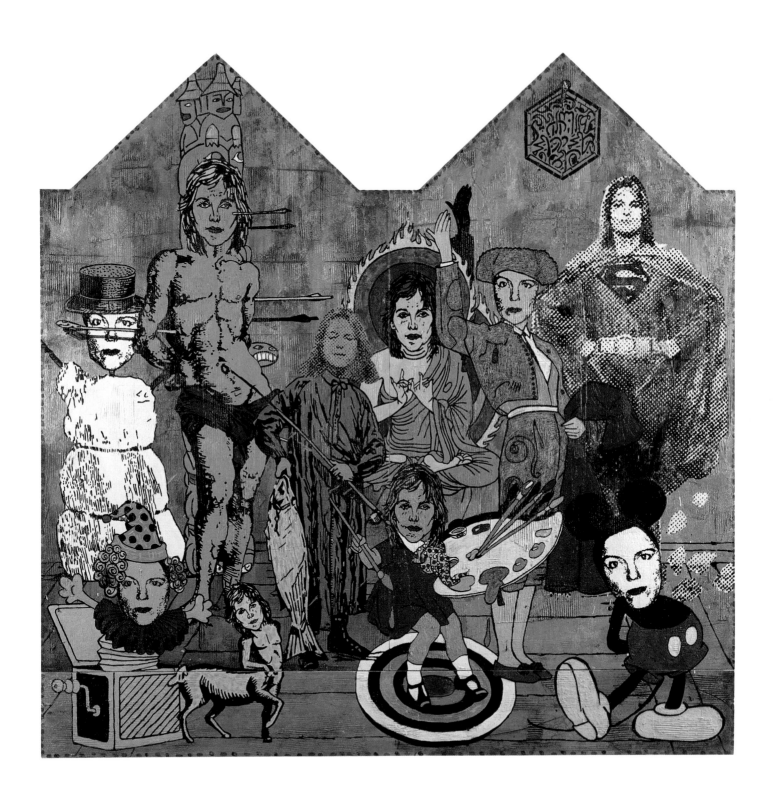

Lobby Card

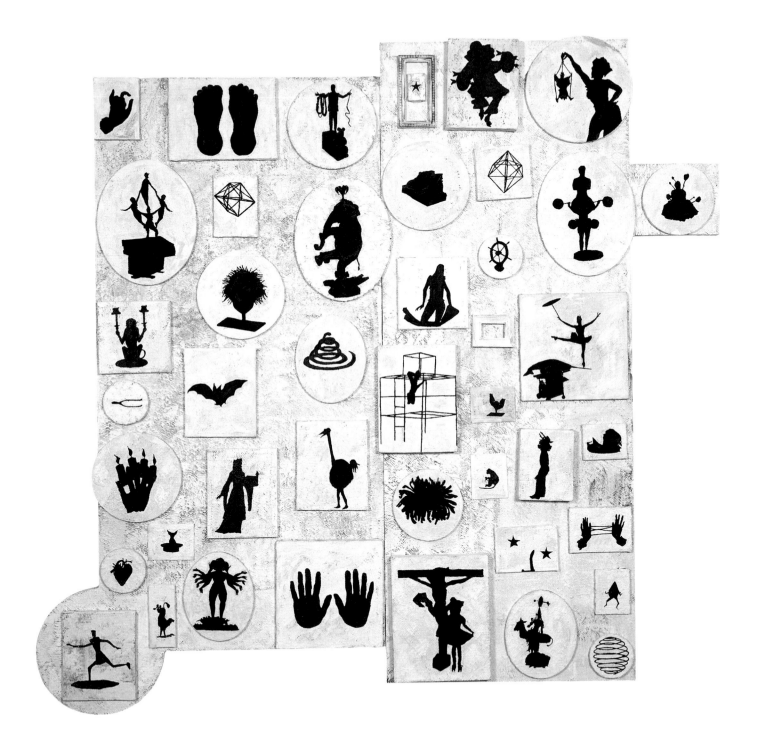

Love You In The Morning

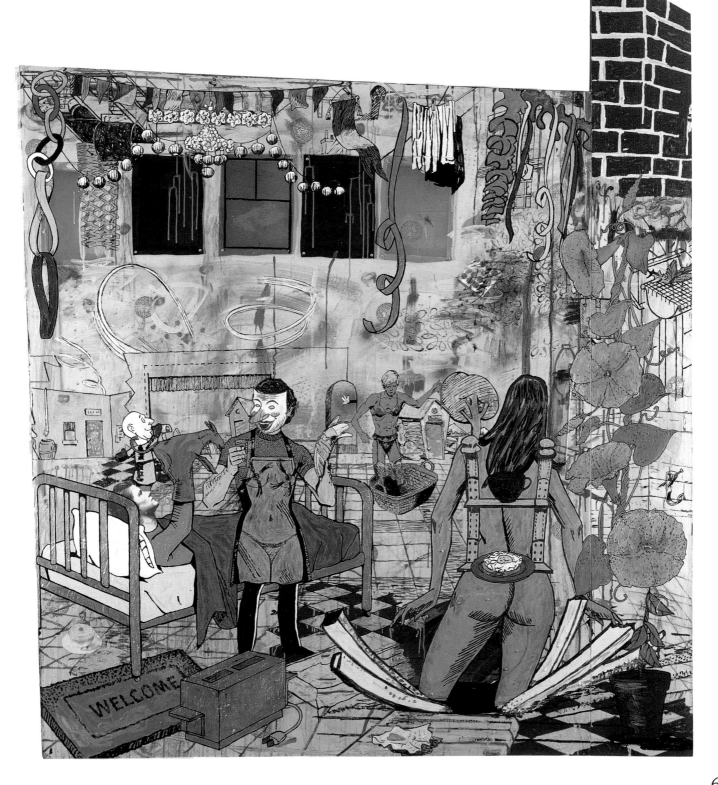

Irregular Plural

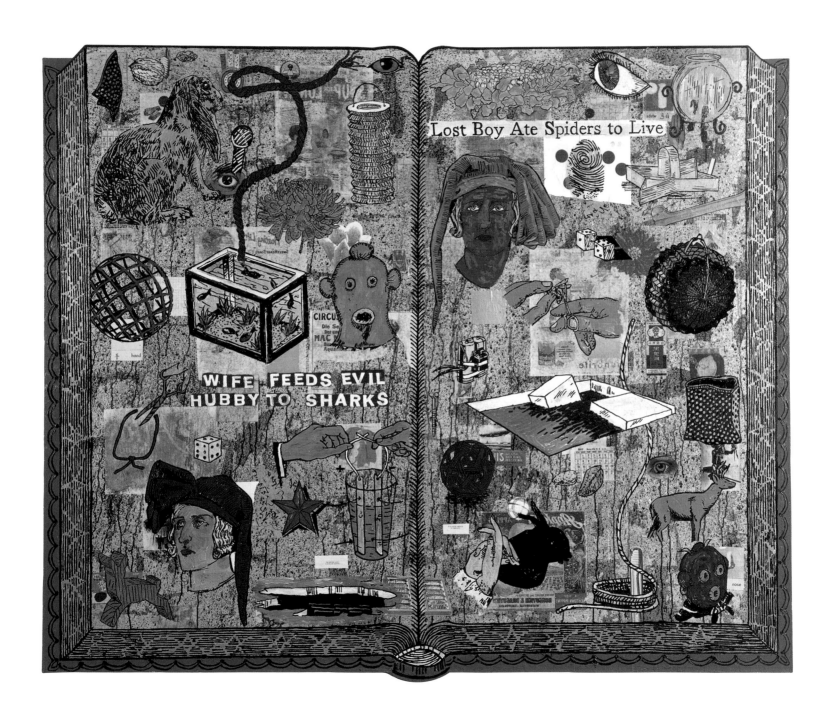

The Wonderfulness of Downtown

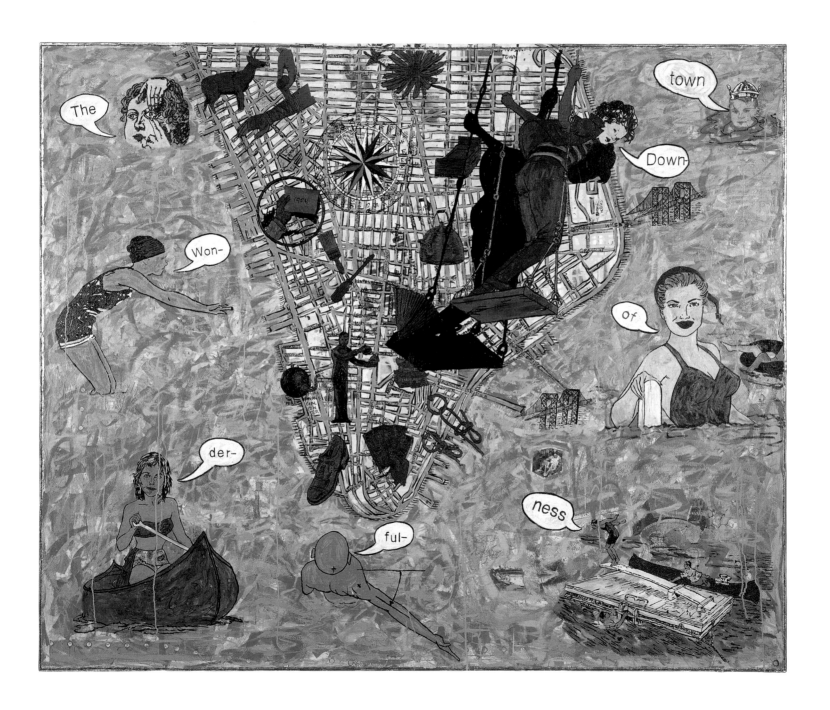

Keeping The Orphan

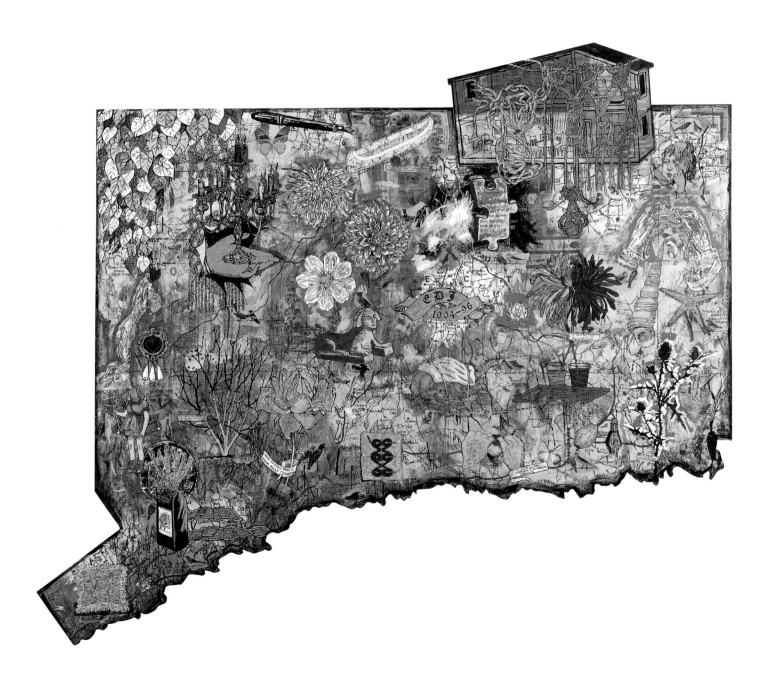

71

Night Stick

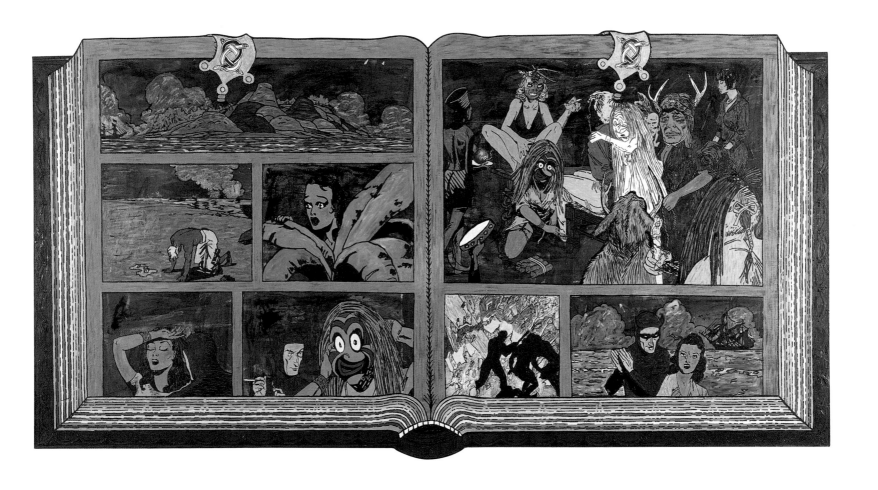

73

Long-Haired Avatar

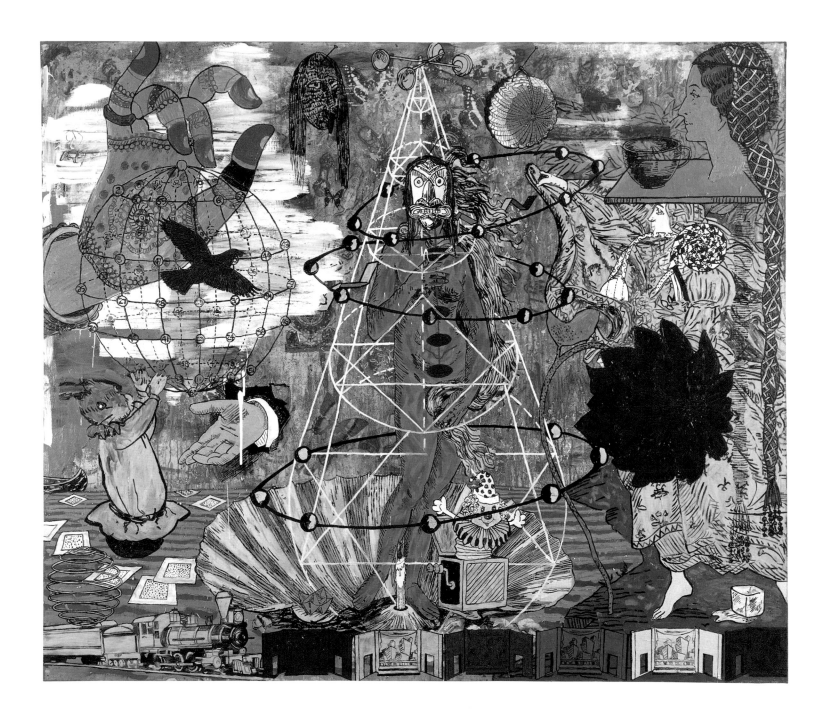

Mad Elga

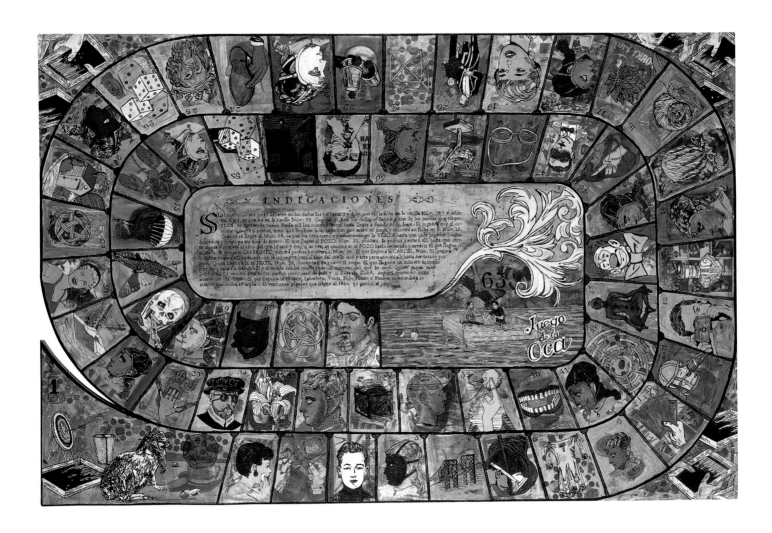

Long Black German Heels and Back Areas

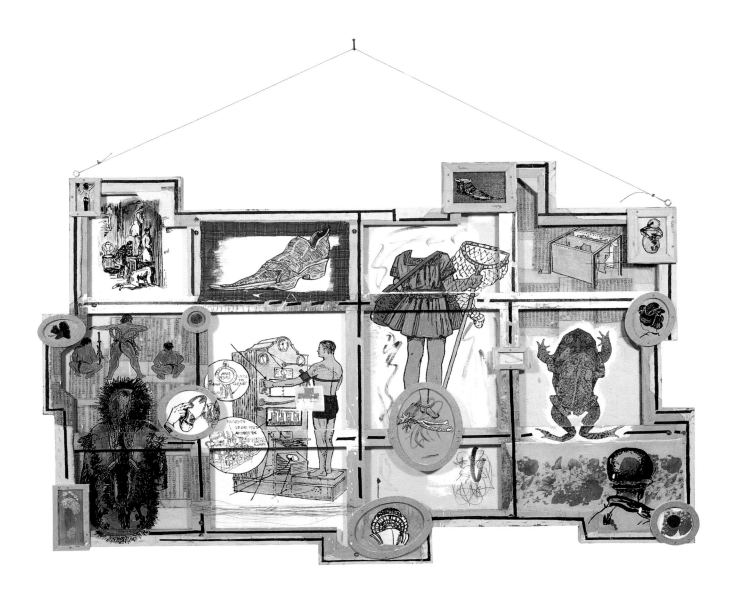

A Parliament of Refrigerator Magnets

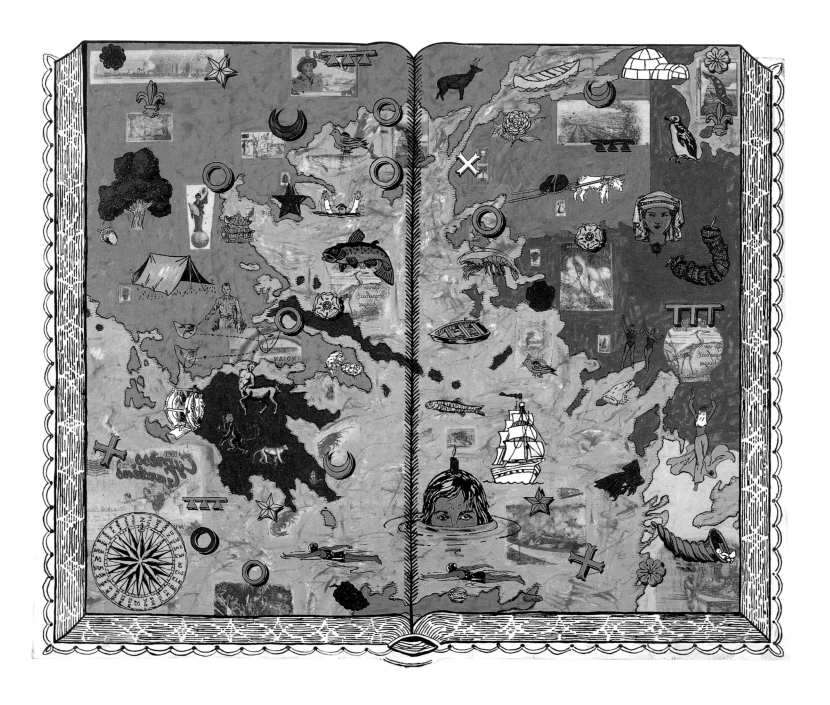

Jill Snyder

Inside The Soapstone Factory

Among the sixty-some paintings created by Jane Hammond in response to an eccentric list of titles supplied by poet John Ashbery is a remarkable series of paintings inspired by a single title, "The Soapstone Factory." As imagined by Hammond, *The Soapstone Factory* is a room, an elegant, classically structured, symmetrically composed room, graced with checkerboard marble floors and arched entrances and windows that would appear to lead out to adjacent chambers or courtyards. Are we in a pavilion, a cloister, a palazzo or, as the title suggests, an abandoned factory? In each variation, the structural permanence of the room stands in stark contrast to a ghostly specter of disparate subjects arrayed within its confines: dancing elephants, meditating Buddhas, clowns on sleds, ballerinas on point, shadow puppets, acrobats, babies and more, are among the changing cast of characters that appear poised, frozen in action, fixed in time. Frequently, the subjects are rendered as black-and-white graphic illustrations set against a color-saturated background, a technique that collapses drawing into painting and conveys the curious appearance of a coloring book left partially undone. What are these mise-en-scènes?

The Soapstone Factory series (1998–1999) offers a prime example of Hammond's playful pictorialism and a lexical key to her art. Like the Surrealists, to whom she owes a conscious debt, Hammond employs the syntax of architecture to suggest more metaphorical, psychological readings. The positioning of subjects within the deeply recessed Soapstone Factory suggests a theatrical space. Curiously, this space permits peeks into adjoining chambers; however, by contrast to the sharply articulated interior space of the main room, these blurred, exterior spaces suggest inchoate, fugitive realms.

A central question for Hammond is how to align painting—the oldest, most traditional of art forms—with the incredible surfeit and constant assault of imagery that defines contemporary life. How can painting accommodate a contemporary consciousness shaped by velocity with a medium that is essentially static? By employing a set number of found images in the paintings created throughout her artistic enterprise, Hammond allows for both stability and contingency. Like a DNA necklace, Hammond's images are reconstituted in endless combinations that bear commonalities of intention and lineage yet sustain new readings as they evolve. Though the paintings that comprise The Soapstone Factory series present singular, fixed worlds, their subjects nevertheless have the potential to tell other stories. Let us, then, imagine The Soapstone Factory series as a theatrical

narrative that engages our anticipation of an unfolding story and which, like Scheherazade's, may span a thousand and one nights.

Act I

Hammond sets a metaphorical stage in the series's first painting, *The Soapstone Factory* (1998). Buddhas and ballerinas join elephants and maidens and others—figures ranging from the historical and religious to the theatrical and natural. Each character is set on its own base and appears to have come to life through a sculptor's labor, as evidenced by the presence of hand carving tools and scattered fragments of stone. As in the Pygmalion myth, the creative act is presented here as a birth metaphor. The central motif is an hourglass, elaborately sandwiched between a plank, a wooden log, a conch shell, and a tea cup, all precariously balanced on the folded legs of a balancing acrobat. Time is poised, ready to be served. The play is about to begin.

Act II

In *The Soapstone Factory #3*, a child is seated center stage, surrounded and enchanted by a representation of the wondrous, the magical, and the entertaining. Joining the now familiar elephant and ballerina are an Indian with tomahawk, a clown, and a magician, the latter appearing to be the impresario of a dance number involving colorful hoops and high kicks. In the near distance, offstage, a clothing line hung with shadow puppets provides a host of characters ready and waiting. A single die is set at the forefront of the stage, suggesting a game of chance, or of life, yet to be played.

Act III

The Soapstone Factory #4 depicts a pan-cultural world, in which the marriage of art and science is consummated. The mounted heads of Andy Warhol, Pablo Picasso, Albert Einstein, and Mahatma Ghandi frame the stage-like setting, avatars of wisdom, knowledge, creativity, and passion; a Buddha, an Indian goddess, two Mayan boys, and a German medieval townsman that occupy the main room embellish the universal scope of the painting. Hammond's ballerina, assuming the role of spirit guide to this narrative, opens her arms in full arabesque to this riotous scene. Resplendent with color that animates its subjects, the painting has a formal beauty and compositional complexity that convey a ripeness and fullness of life. Yet, even in the fullness of life, time is fleeting; Hammond reminds us of this by tucking a metronome into the near right corner. In contradistinction to the human and historical motif of most of the painting, a complex crystal on a small red stand is placed at the center of the painting—a natural object. The crystal, a multi-faceted structure reflective of its environment, in certain cultures is believed to contain healing properties and bear knowledge of the future. These restorative and knowledge-bearing properties become powerful symbols for Hammond's view of art.

Epilogue

Themes of healing, death, and transformation define the narrative of *Good Night Nurse*, a painting with a different Ashbery title but having the same structure as those in The Soapstone Factory series. Culturally defined figures—a knight in armor, a clown—are joined by rabbits, birds, and a moose, subjects from nature. At the painting's center, two boys play a game of leapfrog amidst boyhood paraphernalia, including a baseball mitt, ball, and drums. To the right, a figure borne by a sail wind skates away from the scene. Close inspection reveals that the bases supporting these figures are coffins. Hammond has acknowledged the painting comes from a dream she had that was woven of several parts. Some summers ago she had found a small graveyard in rural Vermont with carved objects atop the stones. Some years before she had seen an exhibit of coffins carved in Ghana, in which the shapes of the coffins—fish, onions, a Mercedes-Benz—related to the deceaseds' occupations. And mixed into the same dream were elements of her nephew's battle with a life-threatening illness. Many of the images seem possibly chosen from the perspective of a young boy. Drawing on ancient reliefs as well as Egyptian belief, Hammond supplies modes of transportation—canoe, sailboat, wind sailing—as means of conveyance to an afterlife. *Good Night Nurse* thus both closes and reopens the bittersweet cycle of life described in this fascinating series of paintings.

Fragmentary yet fluid, Hammond's paintings embrace closure and infinity, choice and chance, the archetype and the individuated. In The Soapstone Factory series Hammond employs a magical pictorialism that builds upon the heterogeneity of postmodernism. She suggests a richly imaginative, polyphonic self that both moves on from the postmodern world and looks back at painting throughout time.

List of Illustrations

Irregular Plural #5, 1999. Oil on canvas with mixed media, 73 x 87 inches. Collection David Teplitzky and Peggy Scott, Evergreen, CO (p. 19)

The Soapstone Factory #3, 1999. Oil on canvas with mixed media, 70 x 88 inches. Collection Bill and Jackie Fromm, Kansas City, MO (p. 21)

Bread and Butter Machine, 2000. Oil and mixed media on wood panel, 78 3/4 inches diameter, 6 inches deep. Private Collection, Chicago, IL (p. 23)

Sore Models #2, 1994. Oil on canvas with metal leaf, 88 x 81 inches overall (two panels). Collection Dr. and Mrs. Robert and Lisa Feldman, Longwood, FL (p. 25)

The Mush Stage, 2001. Oil on canvas with mixed media, 104 x 74 inches. Courtesy the artist and Galerie Lelong, New York (p. 27)

Wonderful You #2, 1996. Oil on canvas with mixed media, 82 1/4 x 86 1/4 inches overall (two panels). Collection the artist (p. 29)

Dumb Show, 1994–1995. Oil on canvas with mixed media, 72 x 86 inches. Collection David Beitzel, New York (p. 31)

Sore Models #3, 1994. Oil on canvas, 70 x 105 inches overall (two panels). Private Collection (p. 33)

The Friendly Sea, 1995. Oil on canvas with mixed media, 85 inches diameter. Collection Cade Roster, Honolulu, HI (p. 35)

Midwife to Gargoyles, 1996. Oil on canvas with mixed media, 74 x 98 inches. Collection Vicki and Kent Logan, Fractional and Promised Gift to the San Francisco Museum of Modern Art (p. 37)

Freezer Burn 1995. Oil on wood panel, 77 inches in diameter. Collection Gary and Joyce Stetson, Highland Park, IL (p. 39)

Wonderful You #3, 1997. Oil and mixed media on canvas and wood, 99 x 120 inches overall (five panels). Private Collection, New York (p. 41)

Surrounded by Buddies, 1993–1994. Oil on canvas, 75 x 76 inches. Private Collection, Oslo, Norway (p. 43)

No One Can Win at the Hurricane Bar, 1998–1999. Oil on canvas with mixed media, 108 x 108 inches overall (three panels). Courtesy the artist and Galerie Lelong, New York (p. 45)

Confessions of a Fop, 1994. Oil on canvas with mixed media, 67 x 39 inches. Collection Gary Sibley, Dallas, TX (p. 47)

Mad Elga, 1996. Oil on canvas with mixed media, 81 x 77 inches. Collection Corrine Lemberg, Bloomfield Hills, MI (p. 49)

RSVP, 1994. Oil on canvas with mixed media, 72 x 86 inches. Collection Peter Norton, Santa Monica, CA (p. 51)

Tom Tiddler's Ground, 1996. Oil on canvas and wood with mixed media, 100 x 90 inches overall (three panels). Collection Robert and Michal Armstrong, Sydney, Australia (p. 53)

The Soapstone Factory #4, 1999. Oil on canvas with mixed media, 74 x 98 inches. Collection Dr. Herbert and Shirley Semler (p. 55)

Sore Models #5, 1995. Oil on canvas, 84 x 58 inches overall (three panels). Collection Jules and Barbara Farber, Trets, France (p. 57)

The National Cigar Dormitory, 1995. Oil on canvas with mixed media, 88 x 83 1/2 inches (two panels). Collection Vicki and Kent Logan, Fractional and Promised Gift to the San Francisco Museum of Modern Art (p. 59)

Wonderful You, 1995. Oil on canvas with mixed media, 81 1/2 x 82 inches overall (three panels). The National Museum of Women in the Arts, Washington, D.C. Promised Gift of Steven Scott, Baltimore, MD, in honor of the artist (p. 61)

Lobby Card, 2000. Oil and encaustic on wood, canvas and lace, 71 x 78 inches. Courtesy Greg Kucera Gallery, Seattle and Galerie Lelong, New York (p. 63)

Love You in the Morning, 1997. Oil on canvas with mixed media and Plexiglas, 100 x 86 inches overall (two panels). Private Collection, New York (p. 65)

Irregular Plural #3, 1995. Oil on canvas with mixed media, 61 x 73 inches. Collection Hans v. d. Oever and Willeke Stuart, Amsterdam, The Netherlands (p. 67)

The Wonderfulness of Downtown, 1994. Oil on canvas with mixed media, 72 x 86 inches. Collection Gary Sibley, Dallas, TX (p. 69)

Keeping the Orphan, 1997. Oil on canvas with mixed media, 114 x 137 inches overall (three panels). Private Collection, New York (p. 71)

Night Stick, 1996. Oil on canvas with mixed media, 62 x 117 1/2 inches. Collection Sharon and Thurston Twigg-Smith, Honolulu, HI (p. 73)

Long-Haired Avatar, 1995. Oil on canvas with mixed media, 72 x 86 inches. Collection Peter and Eileen Broido, West Chicago, IL (p. 75)

Mad Elga #2, 1997. Oil on canvas with mixed media, 69 x 102 inches. Collection The Detroit Institute of Arts, Founders Society Purchase, Dr. and Mrs. George Kamperman Fund, with funds from Joan Ortiz (p.77)

Long Black German Heels and Back Areas, 1996. Oil on canvas with mixed media, 95 x 106 inches (including wire). Collection Arlene and Barry Hockfield, Penn Valley, PA (p. 79)

A Parliament of Refrigerator Magnets, 1994. Oil on canvas with mixed media, 73 x 87 1/2 inches. Collection Robert Lehrman, Washington, D.C. (p. 81)

Jane Hammond was born in Bridgeport, Connecticut, in 1950 and was educated at Mt. Holyoke College and the University of Wisconsin at Madison. She moved to New York City in 1980. In 1989 the first solo show of her paintings was mounted at Exit Art in New York. Since then she has had seven solo exhibitions in New York and other solo exhibitions in Stockholm, Amsterdam, Barcelona, Milan, Detroit, Chicago, Seattle, and Los Angeles. Solo museum exhibitions have been organized in 1993 at the Honolulu Academy of Art, in 1993 at the Cincinnati Art Museum, and in 1994 at the Orlando Museum of Art.

Her paintings have been written about in *The New York Times, The Los Angeles Times, Art in America, The New Yorker, Artforum, Art News, Art & Antiques, The Village Voice, Flash Art, Arts Magazine*, and many other publications.

She is the recipient of the Louis Comfort Tiffany Foundation Grant, the Ludwig Vogelstein Foundation Grant in Painting, two New York State Council on the Arts Grants, the National Endowment for the Arts Fellowship, and the Joan Mitchell Foundation Grant Award. Ms. Hammond lives in New York City where she is represented by Galerie Lelong.

Selected Public Collections

Albertina, Vienna, Austria
Albright-Knox Art Gallery, Buffalo, NY
Art Institute of Chicago
Baltimore Museum of Art
Biblioteque Nationale, Paris, France
Brooklyn Museum of Art
Cincinnati Art Museum
The Contemporary Museum, Honolulu
The Detroit Institute of the Arts
The Fogg Art Museum, Harvard University, Cambridge, MA
Grunewald Center for Graphic Arts, University of California, Los Angeles
Maryland Institute College of Art
Museo de Arts Contemporaneo, Mexico City
Metropolitan Museum of Art, New York
Milwaukee Art Museum
Museum of Contemporary Art, Chicago
Museum of Fine Arts, Boston
Museum of Modern Art, New York
New York Public Library
Orlando Museum of Art
Portland Art Museum, Portland, OR
Saint Louis Art Museum
San Francsico Museum of Modern Art
Toledo Museum of Art
The Walker Art Center, Minneapolis
Weatherspoon Art Gallery, University of North Carolina, Greensboro
The Whitney Museum of American Art, New York
Yale University Art Museum, New Haven

John Ashbery was born in Rochester, New York, in 1927, grew up on a farm in western New York State, and was educated at Harvard and Columbia universities. In 1955 he went to France as a Fulbright Scholar, and lived and worked there for ten years. He began writing about art in 1957, served as executive editor of *Art News* (1965–72), and art critic for *New York* magazine (1975-80) and *Newsweek* (1980–85). A selection of his art writings was issued in 1989 as *Reported Sightings: Art Chronicles 1957–1987*, edited by David Bergman (Knopf paperback: Harvard University Press, 1991). Best known as a poet, he has published more than twenty collections. His work has been translated into more than twenty languages. His *Self-Portrait in a Convex Mirror* (Viking, 1975) won the three major American prizes: the Pulitzer Prize, the National Book Critics' Circle Award, and the National Book Award. In 1985 he was awarded a MacArthur Fellowship. His books of poetry include, most recently, *Wakefulness* (1998), *Girls on the Run* (1999), and *Your Name Here* (2000), all from Farrar, Straus and Giroux. He delivered the *Charles Eliot Norton Lectures* at Harvard in 1989–90, published as *Other Traditions* (Harvard University Press, 2000). Since 1990 he has been the Charles P. Stevenson, Jr. Professor of Languages and Literature at Bard College in Annandale-on-Hudson, New York. Mr. Ashbery lives in New York City and Hudson, New York.

Cleveland Center for Contemporary Art